Mary Cassatt

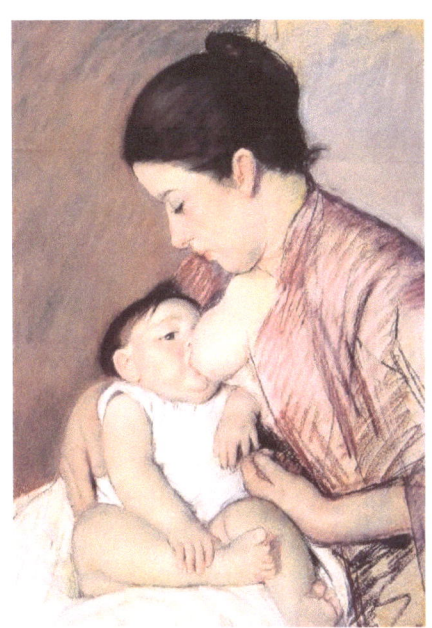

Edited by Lacey Belinda Smith

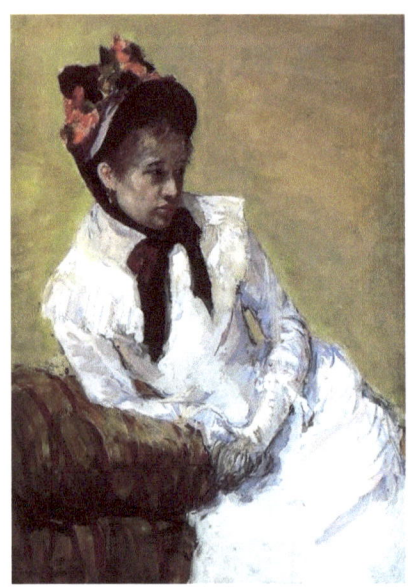

Portrait Of The Artist—1878--Impressionism

Mary Stevenson Cassatt (1844 – 1926) was an American painter and printmaker born in Allegheny City—now part of Pittsburgh, Pennsylvania. Mary Cassatt was one of the leading artists in the Impressionist movement of the later part of the 1800s. Cassatt often created images of the social and private lives of women especially with children.

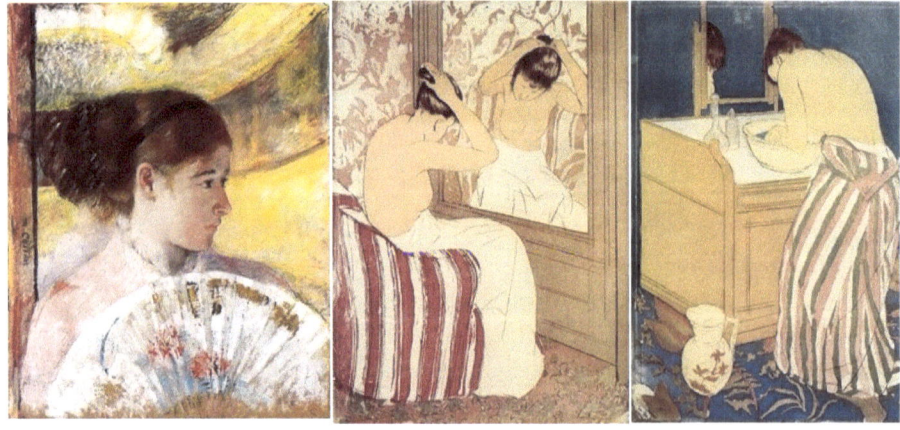

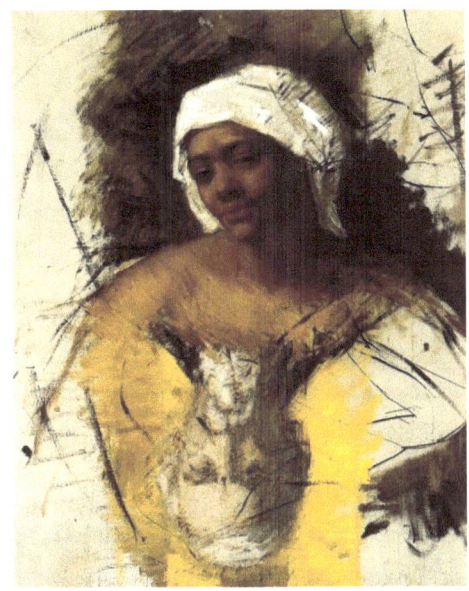

Sketch Of Mrs. Currey—1871—Realism

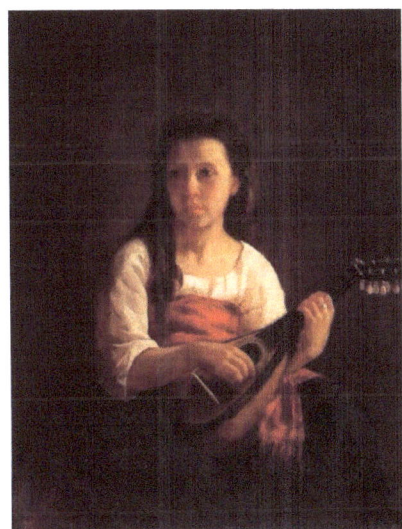

The Mandolin Player—1872--Realism

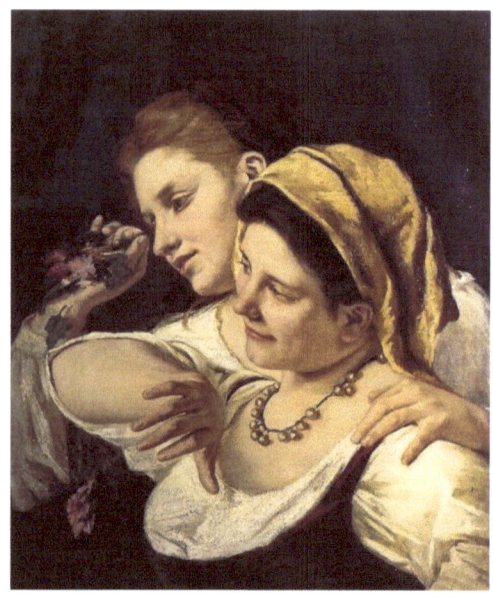

During Carnival—1872-- Realism

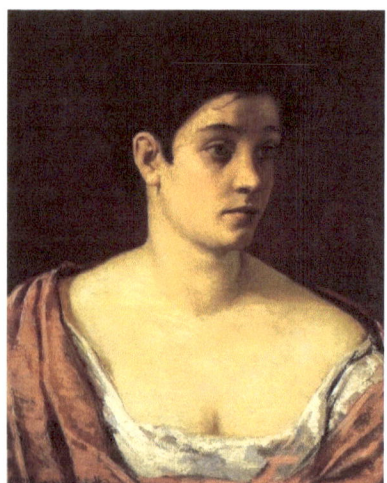

Portrait Of A Woman—1872-- Realism

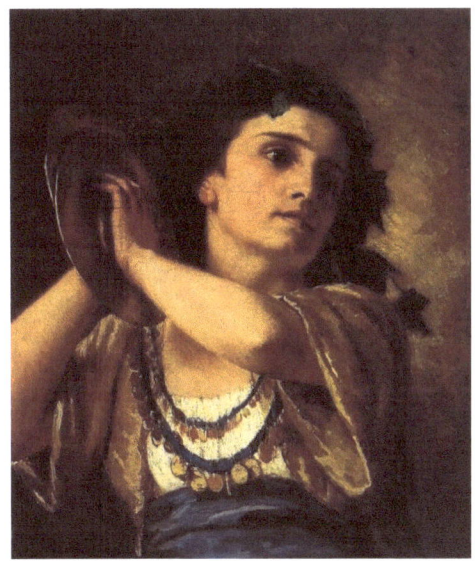

Bacchante—1872-- Realism

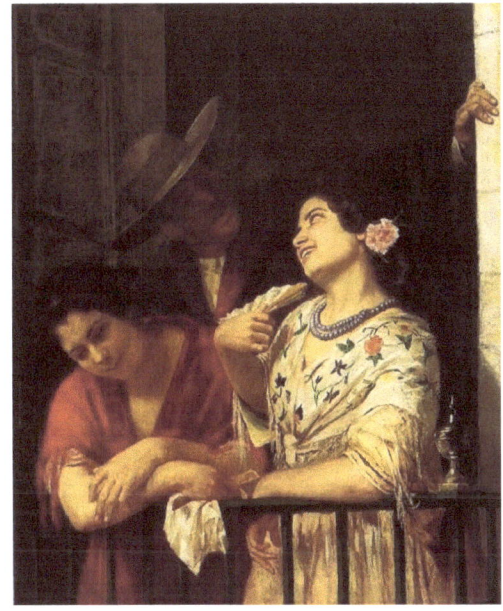

The Flirtation A Balcony In Seville—1872-- Realism

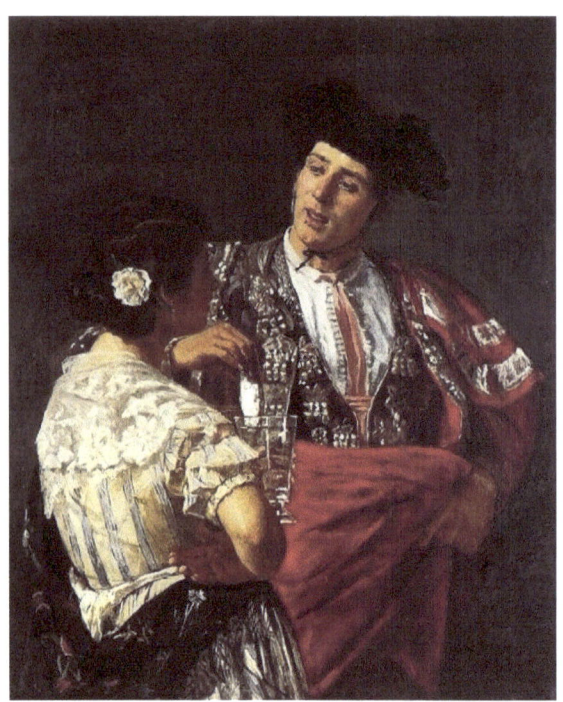

Offering The Panel To The Bullfighter--1872-1873-- Realism

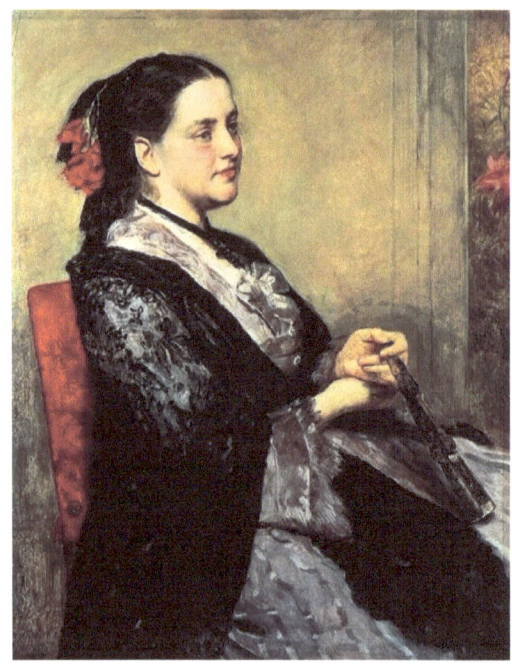

Portrait Of A Lady Of Seville—1873-- Realism

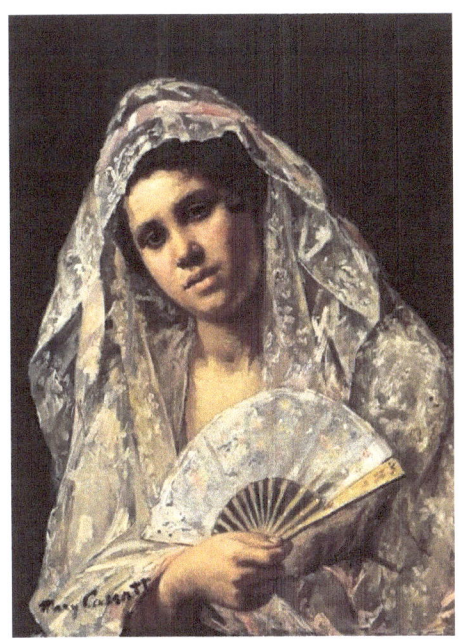

Spanish Dancer Wearing A Lace Mantilla—1873-- Realism

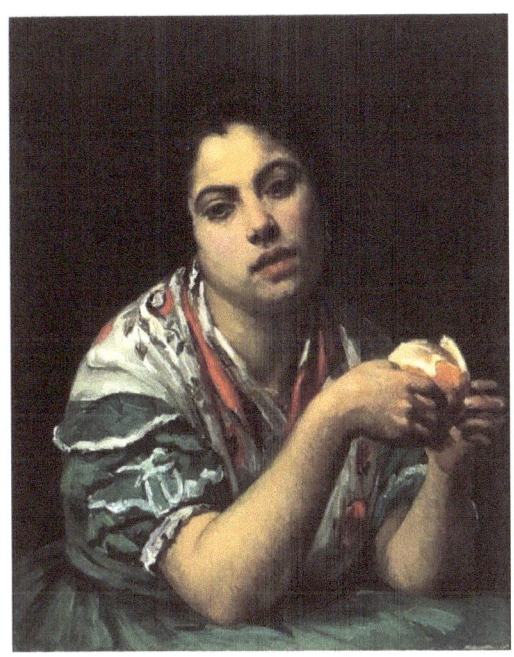

Peasant Woman Peeling An Orange—1875-- Realism

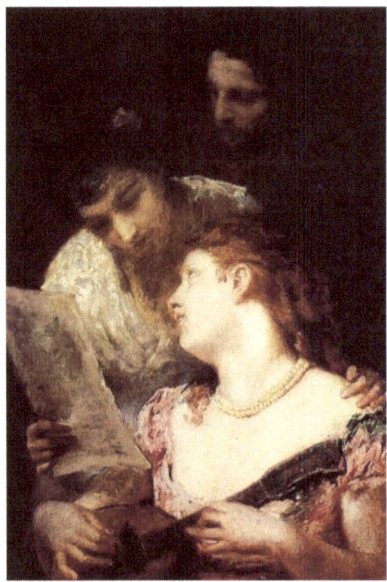

Musical Party—1874-- Realism

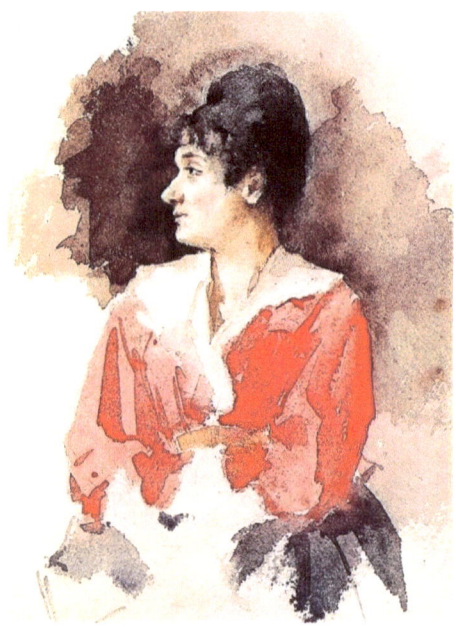

Profile Of An Italian Woman—1873-- Impressionism

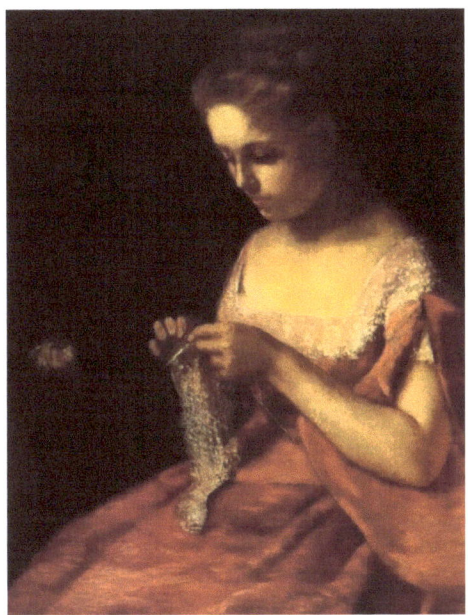

The Young Bride—1875--Realism

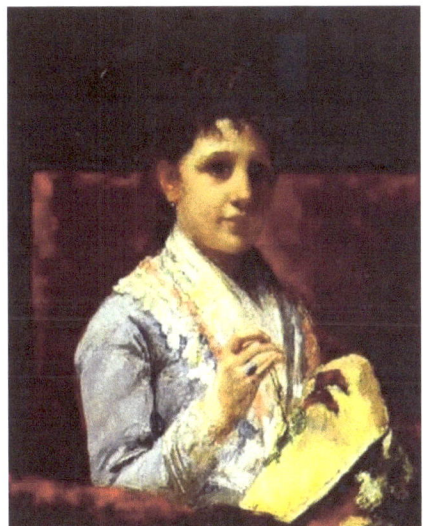

Mary Ellison Embroidering—1877-- Realism

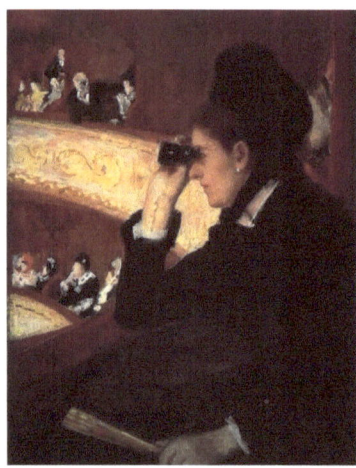

The Opera--1877-1878--Realism

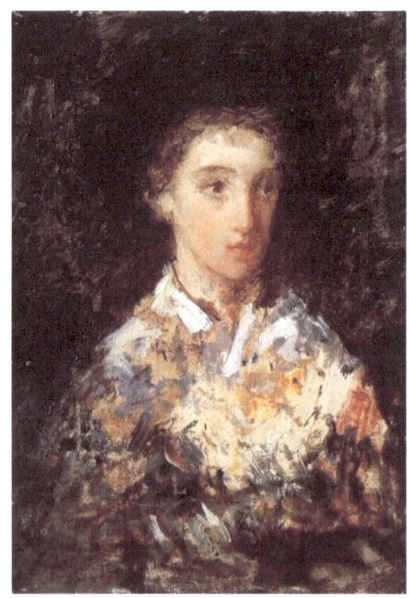

Head Of A Young Girl—1876--Impressionism

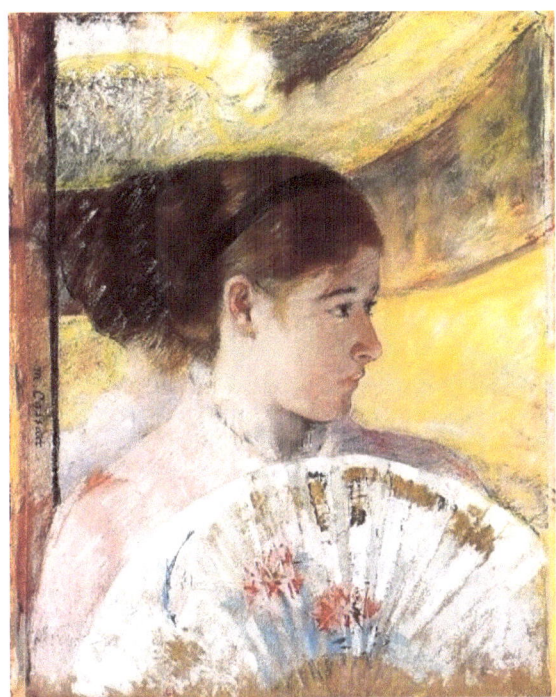

At The Theater--1878-1879--Impressionism

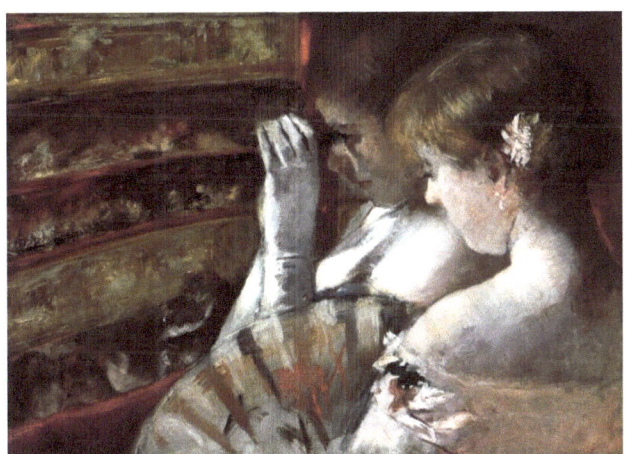

In The Box—1879--Impressionism

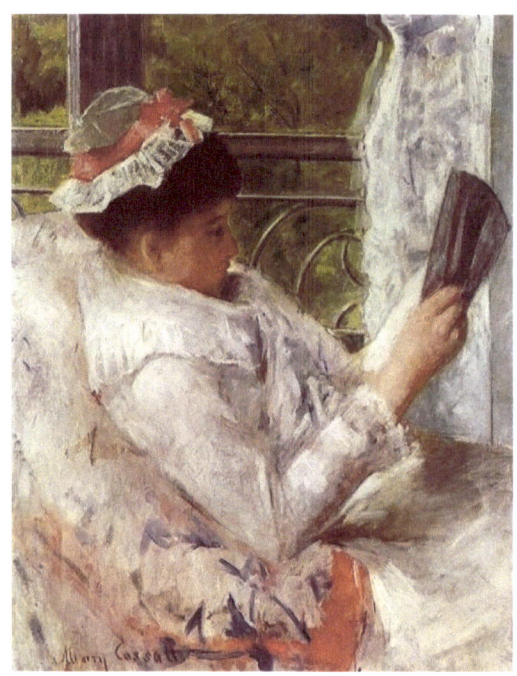

The Reader—1878--Impressionism, Realism

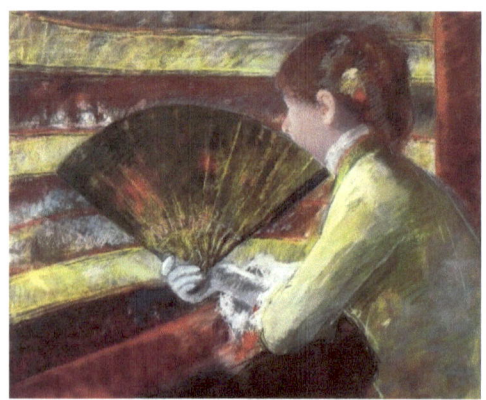

Theater—1879--Impressionism

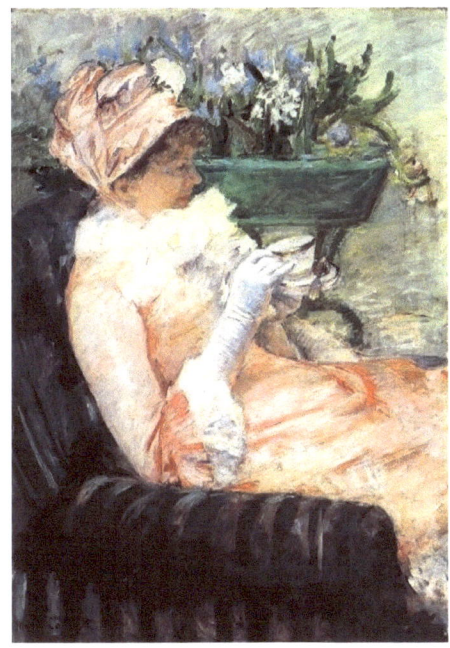

The Cup Of Tea—1879--Impressionism

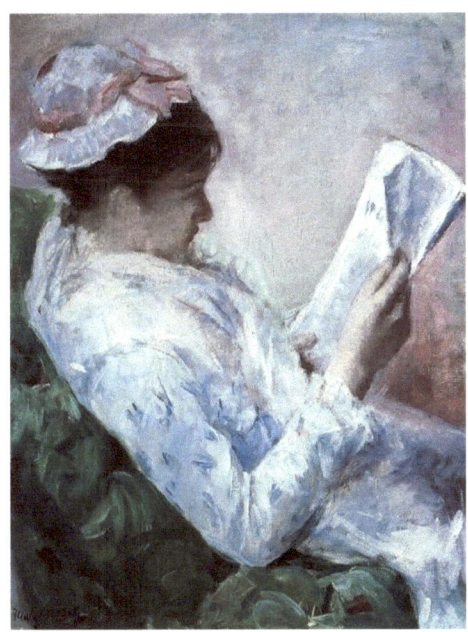

Woman Reading--1878-1879-- Impressionism

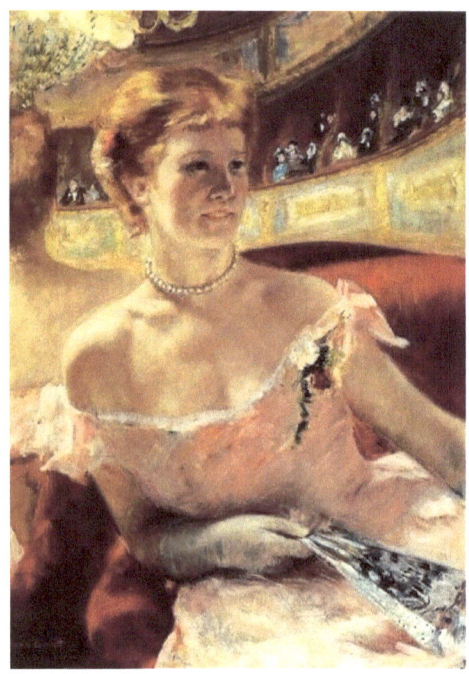

Woman With A Pearl Necklace—1879--Impressionism

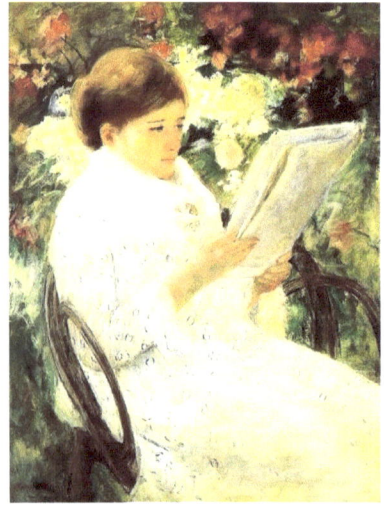

Woman Reading In A Garden—1880--Impressionism

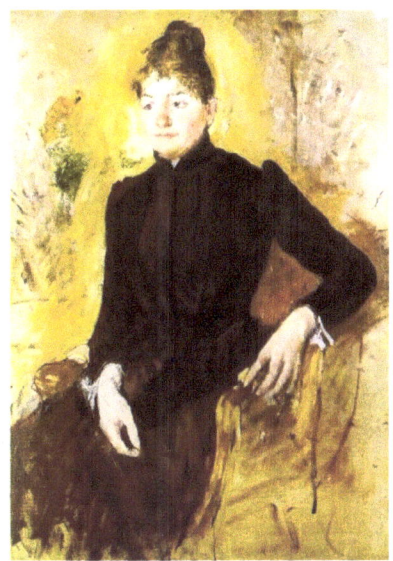

Woman In Black—1882--Impressionism

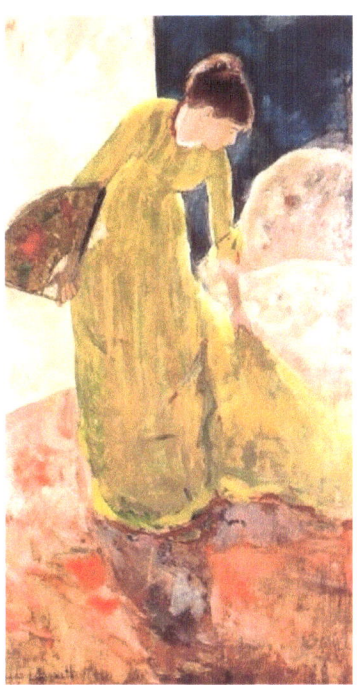

Woman Standing, Holding A Fan--1878-1879-- Impressionism

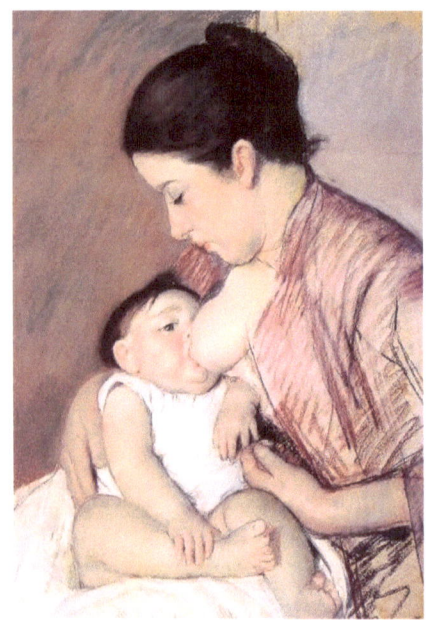

Maternity—1890--Impressionism

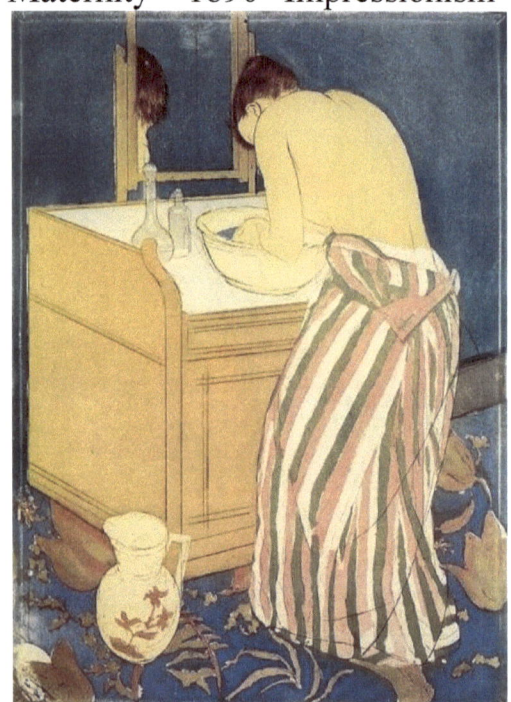

The Bath--1890-1891--Japonism

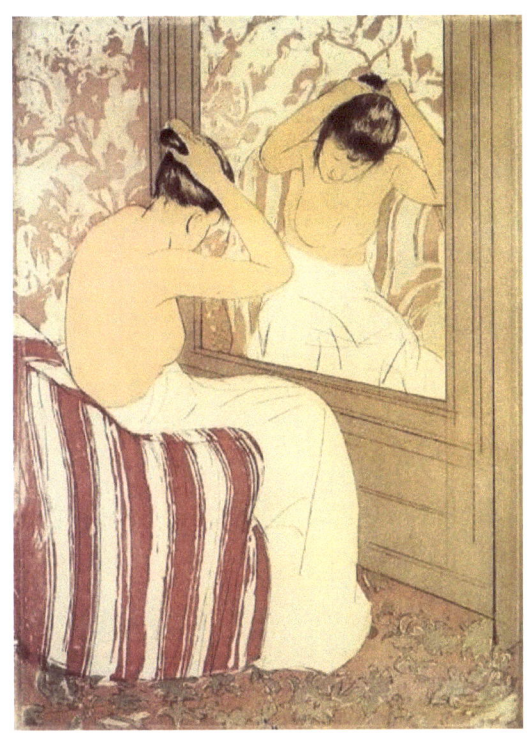

The Coiffure Study--1890-1891-- Impressionism, Japonism

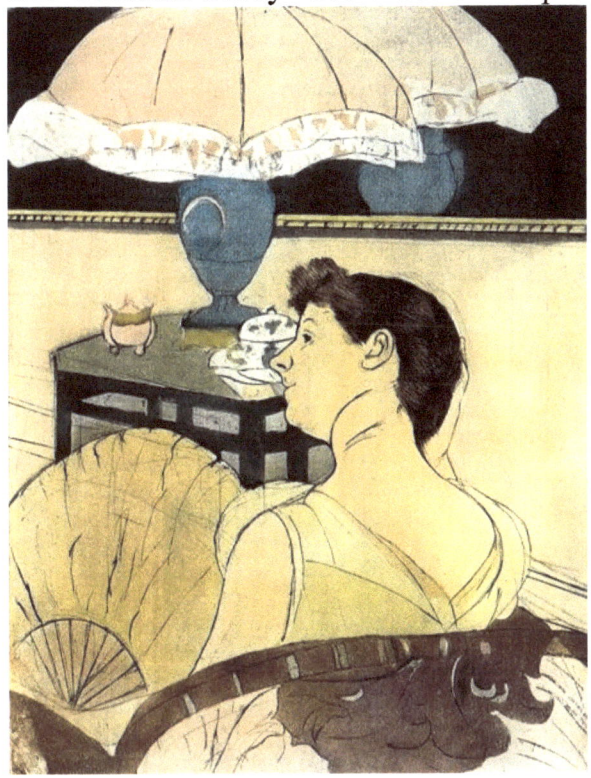

The Lamp--1890-1891--Impressionism, Japonism

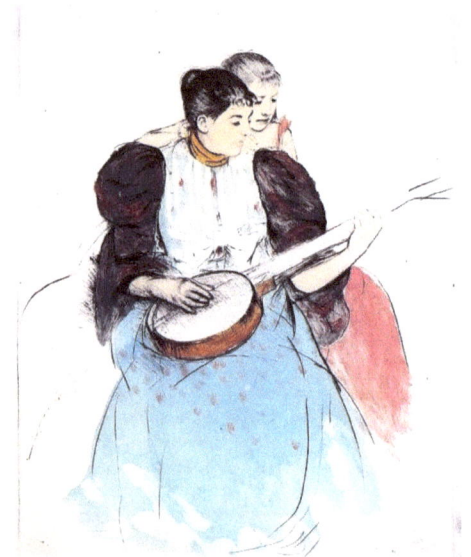

The Banjo Lesson—1893-- Impressionism, Japonism

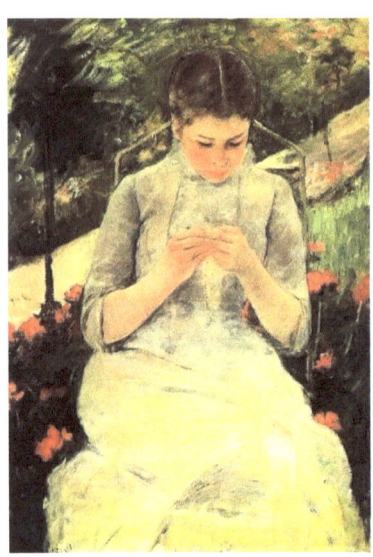

Young Woman Sewing In The Garden--1880-1882-- Impressionism

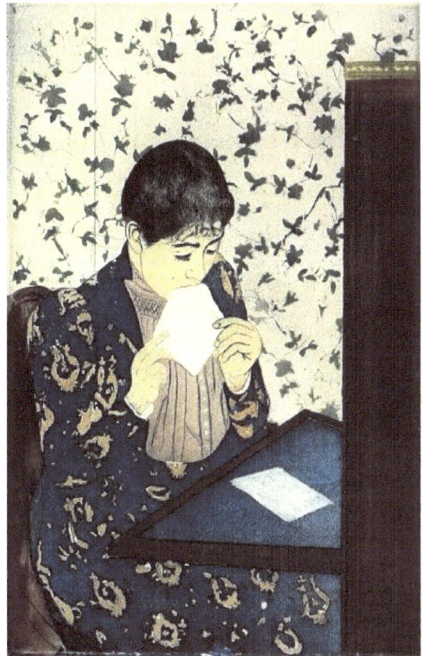

The Letter--1890-1891--Japonism

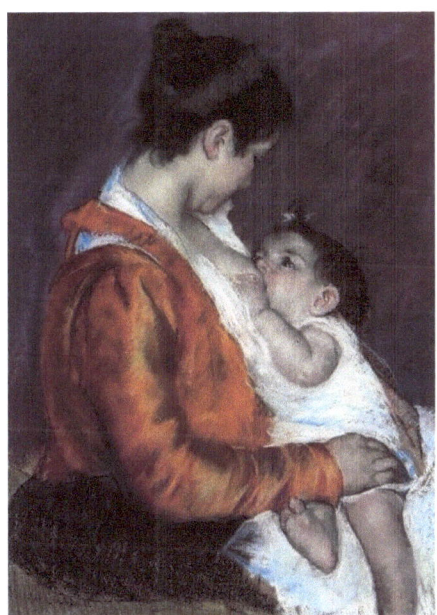

Louise Nursing Her Child—1898-- Impressionism

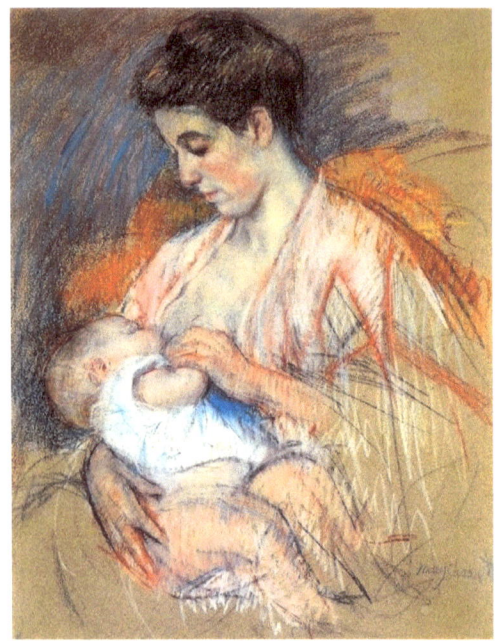

Mother Jeanne Nursing Her Baby--1907-1908-- Impressionism

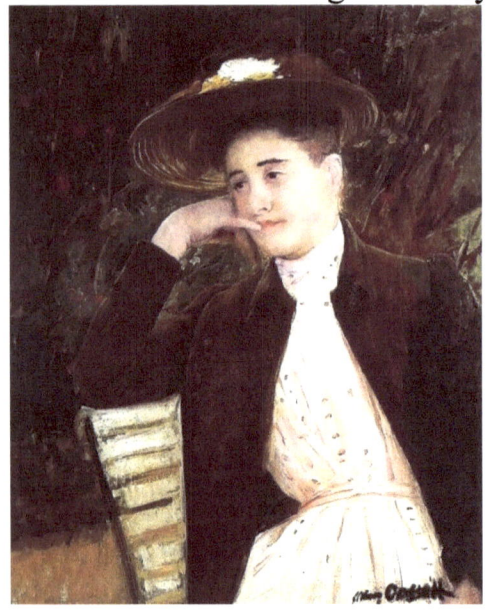

Celeste In A Brown Hat—1891--Impressionism

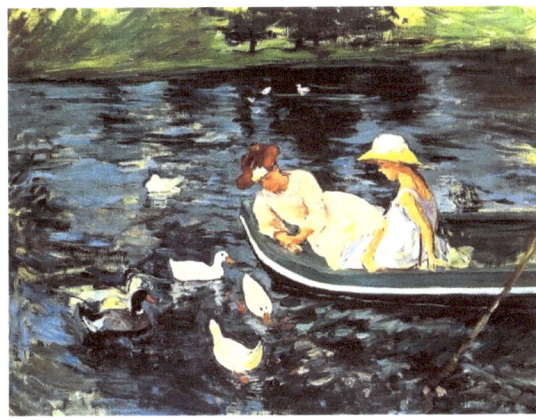

Summertime—1894--Impressionism

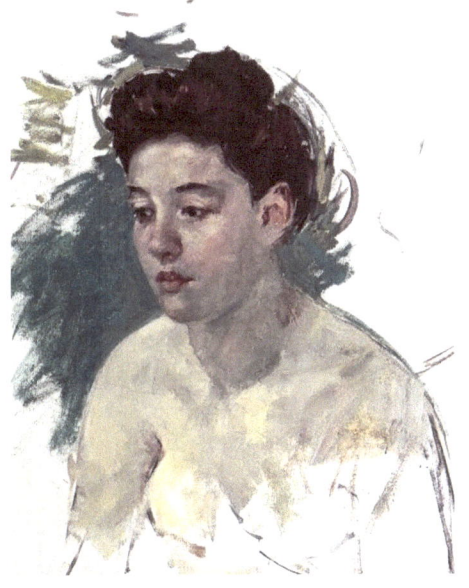

Sketch Of Antoinette (No.1)—1901--Impressionism

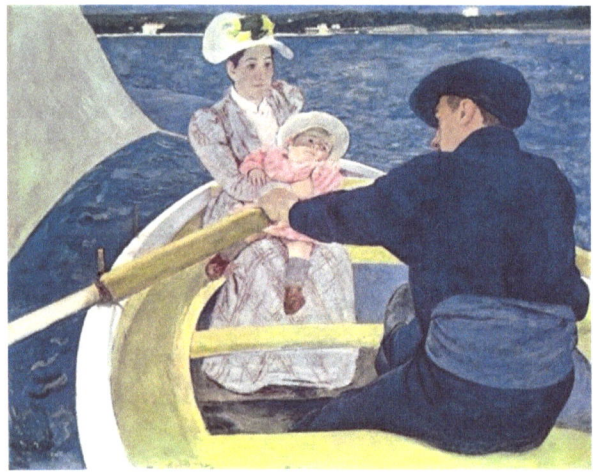

The Boating Party--1893-1894--Impressionism

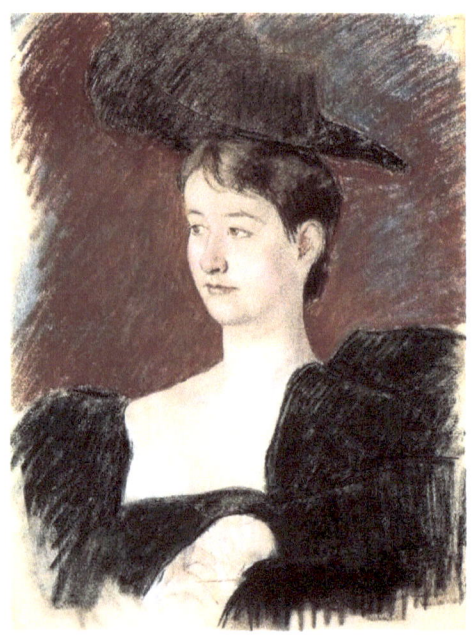

Portrait Of A Young Woman In Green—1898-- Impressionism

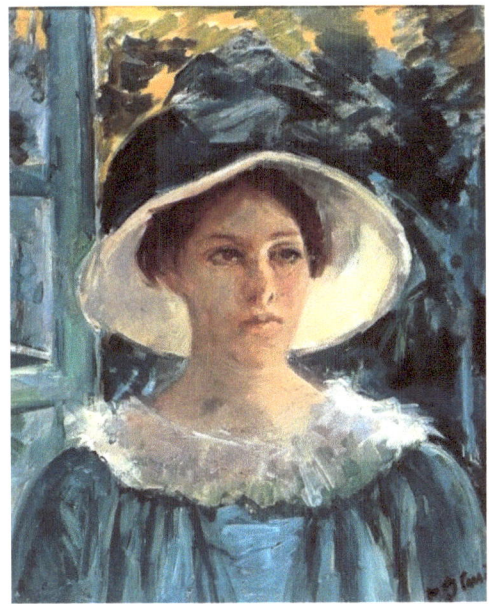

Young Woman In Green Outdoors In The Sun—1914-- Impressionism

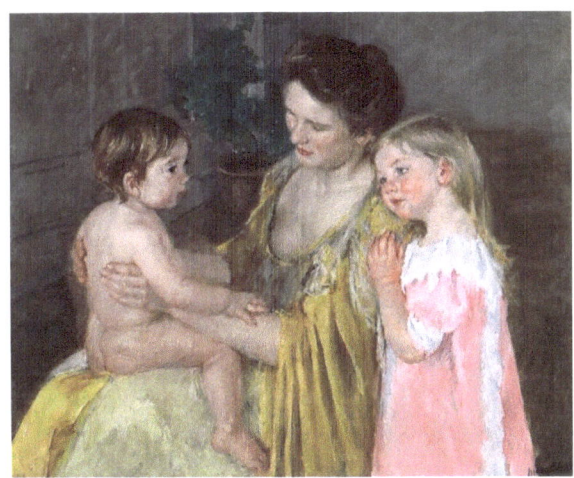

Mother And Two Children—1906--Impressionism

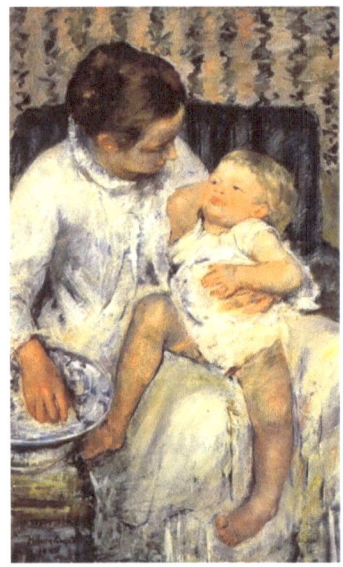

Mother About To Wash—1880-- Impressionism

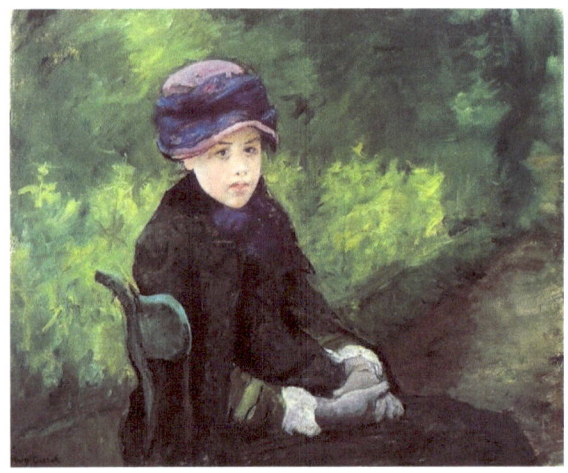

Susan Seated Outdoors Wearing A Purple Hat—1881--Impressionism

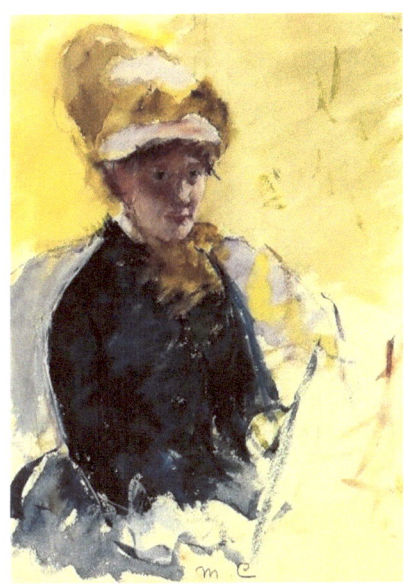

Self Portrait—1880-- Impressionism

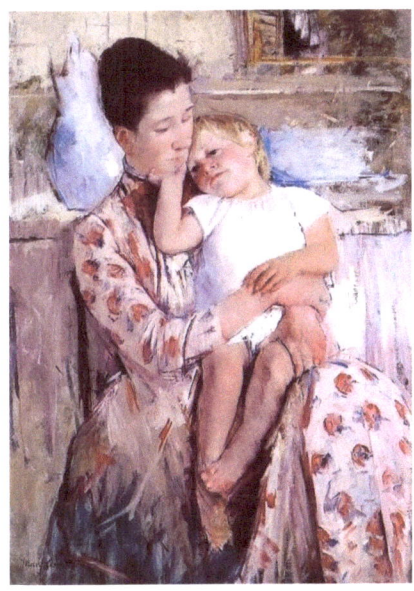

Emmie And Her Child—1889-- Impressionism

www.ingramcontent.com/pod-product-compliance
Lightning Source LLC
Chambersburg PA
CBHW050435180526
45159CB00006B/2551